Perugino's Path

The Journey of a Renaissance Painter

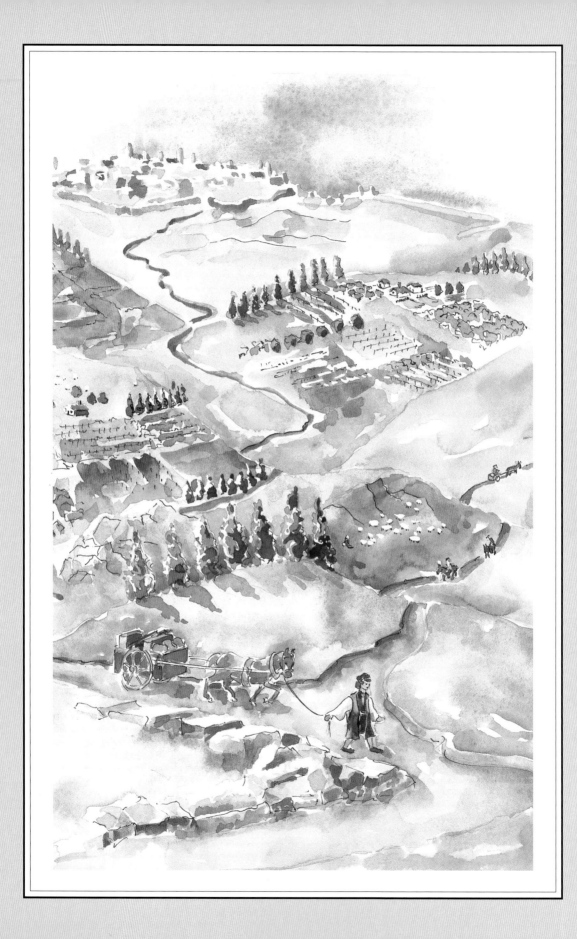

Perugino's Path
The Journey of a Renaissance Painter

Author and Illustrator
Nancy L. Clouse

The Grand Rapids Art Museum

William B. Eerdmans Publishing Company
Grand Rapids, Michigan/Cambridge, U.K.

Joseph Antenucci Becherer, art history consultant

Sandra G. DeGroot, project developer

Copyright © 1997

William B. Eerdmans Publishing Company
255 Jefferson Ave. SE
Grand Rapids, Michigan 49503
also
P.O. Box 163, Cambridge CB3 9PU U.K.

**Library of Congress
Cataloging-in-Publication Data**
Clouse, Nancy L.
 Perugino's Path : the journey of a
renaissance painter / author and illustrator,
Nancy L. Clouse.
 p. cm.
 ISBN 0-8028-3849-9 (cloth : alk. paper)
 1. Perugino, ca. 1450-1523. 2. Painters —
Italy — Biography. I. Title.
ND623.P4C52 1997
759.5—dc21 97–24641
 CIP

In memory of my friend and neighbor
Kathryn E. Zabel,
whose interest and humor brought
additional joy to this project.

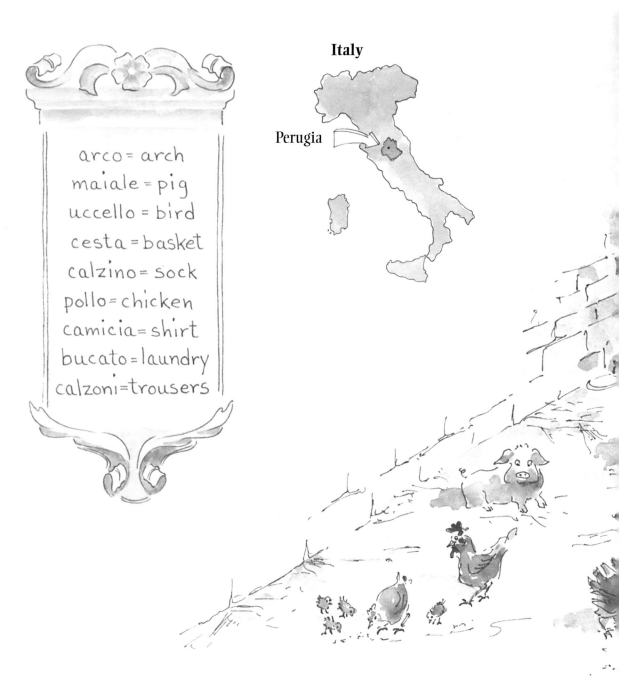

\mathcal{P}ietro Perugino (c. 1450–1523) was an artist in Italy during the Renaissance, a time of great excitement about learning and art. He was born Pietro di Cristoforo di Vannucci, near Perugia, a city in the Italian province of Umbria, but he came to be known as *Il Perugino*, "the one from Perugia."

Italy

Perugia

arco = arch
maiale = pig
uccello = bird
cesta = basket
calzino = sock
pollo = chicken
camicia = shirt
bucato = laundry
calzoni = trousers

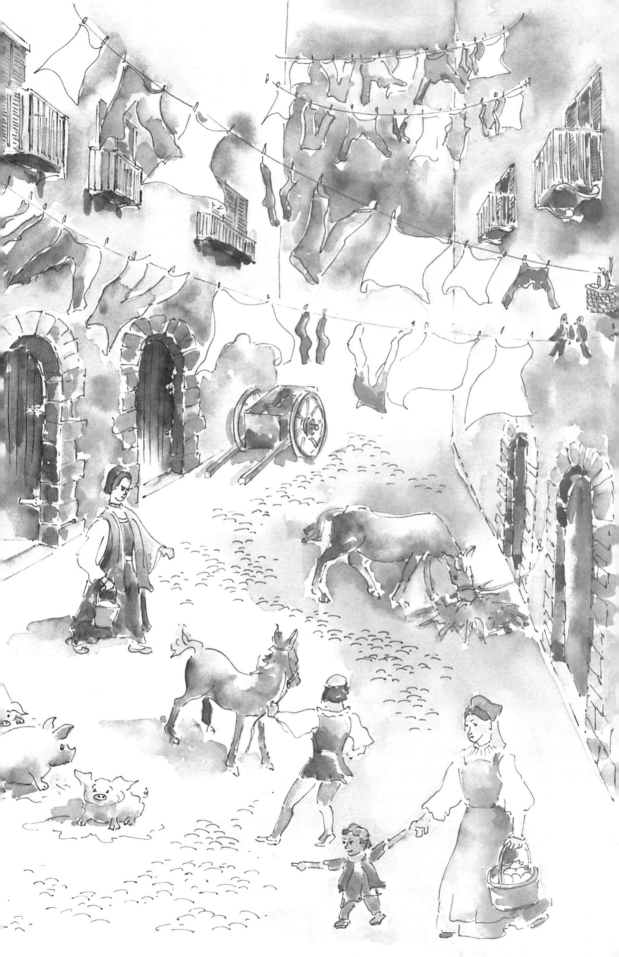

As a young boy, Perugino became an apprentice in the studio of a master artist. There he sanded wooden panels and covered their surfaces with sizing, a mixture of plaster and glue that sealed the wood. Then he applied smooth layers of plaster over the sizing until the surface was ready to be painted by the master.

Besides teaching him how to prepare a wooden surface for painting, Perugino's master showed him how to mix pigments with water and egg yolk to make a kind of paint called egg tempera. The pigments in this paint were colored powders made from minerals, berries, flowers, and various other organic materials.

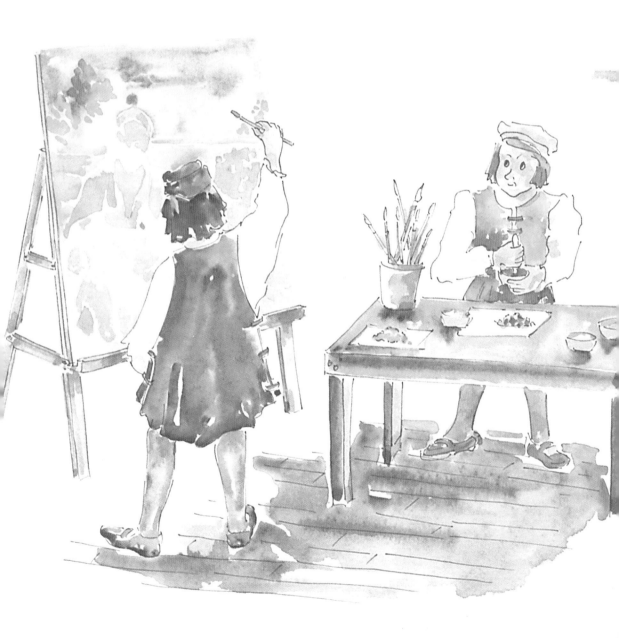

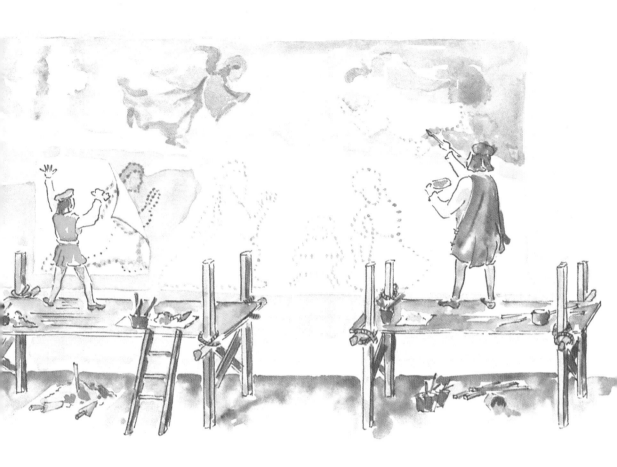

*H*is master also taught Perugino the various steps for making a fresco, which is a picture painted on damp plaster. Before the fresco could be painted, the artist's preliminary drawing—called a cartoon—had to be transferred to the rough plaster of a wall or ceiling. To transfer a cartoon, an apprentice would make holes along the outline of the cartoon and rub charcoal along the outline after the cartoon was hung against a wall or ceiling. The charcoal would go through the holes and leave dotted lines on the plaster underneath. Usually someone would connect the dots into solid lines. Perugino often did this job. Finally, the master and the more experienced apprentices would paint the picture. Frescoes had to be created in small sections because the plaster had to remain damp until the final paint was applied.

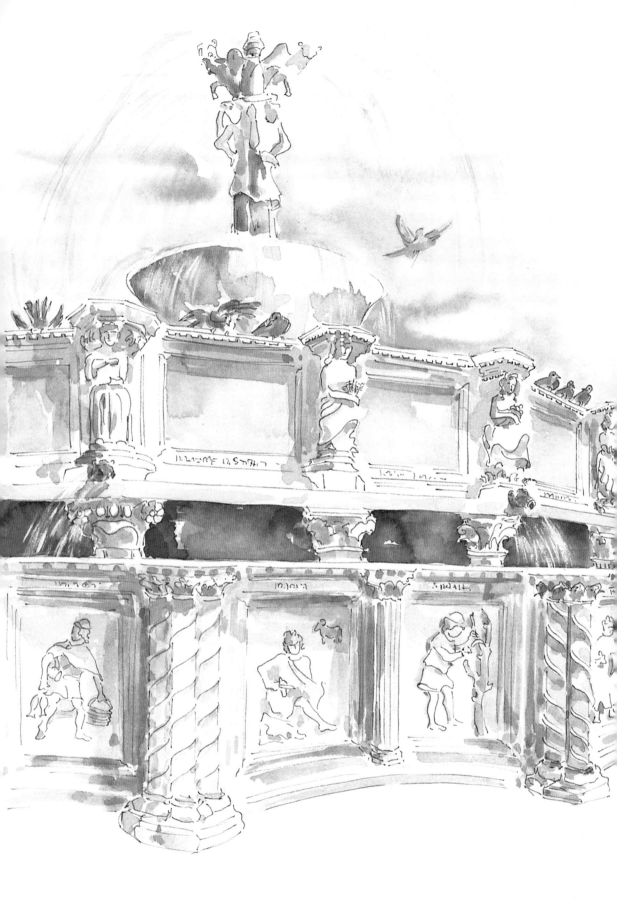

\mathcal{E}ach morning as he walked to his master's workshop, Perugino passed the wonderful Fontana Maggiore. This fountain was an important monument in Perugia. It had been made in the workshop of Nicola and Giovanni Pisano of Pisa. Carved in its stone were figures from Aesop's fables as well as Bible characters such as Adam and Eve and David slaying the giant Goliath. Perugino slowed down to look at these figures and to watch the pigeons take their morning bath in the sunshine.

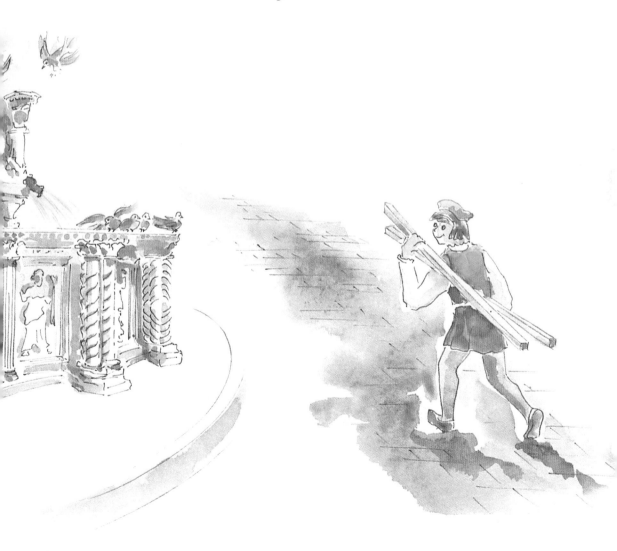

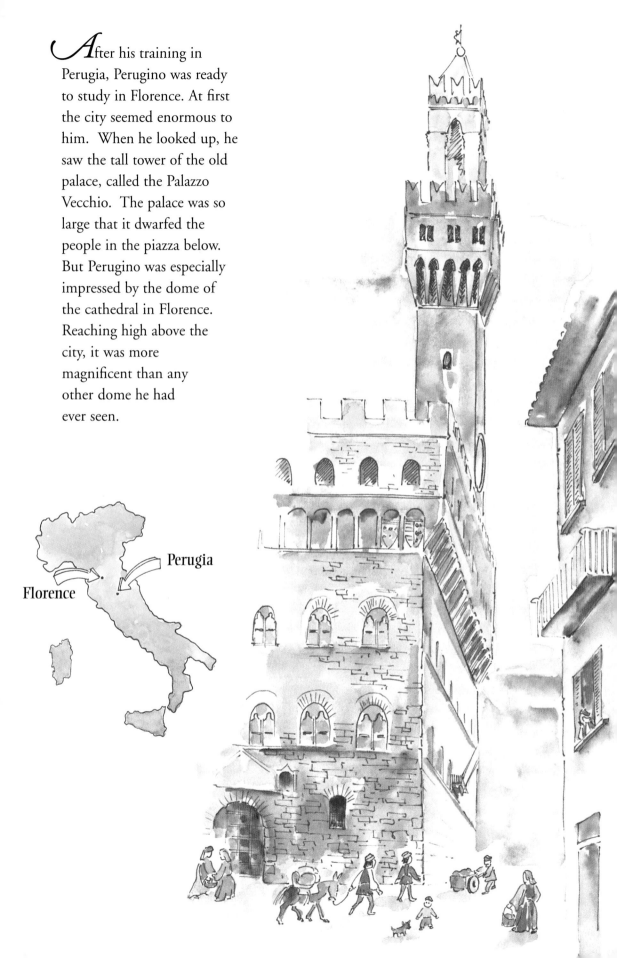

After his training in Perugia, Perugino was ready to study in Florence. At first the city seemed enormous to him. When he looked up, he saw the tall tower of the old palace, called the Palazzo Vecchio. The palace was so large that it dwarfed the people in the piazza below. But Perugino was especially impressed by the dome of the cathedral in Florence. Reaching high above the city, it was more magnificent than any other dome he had ever seen.

Perugia

Florence

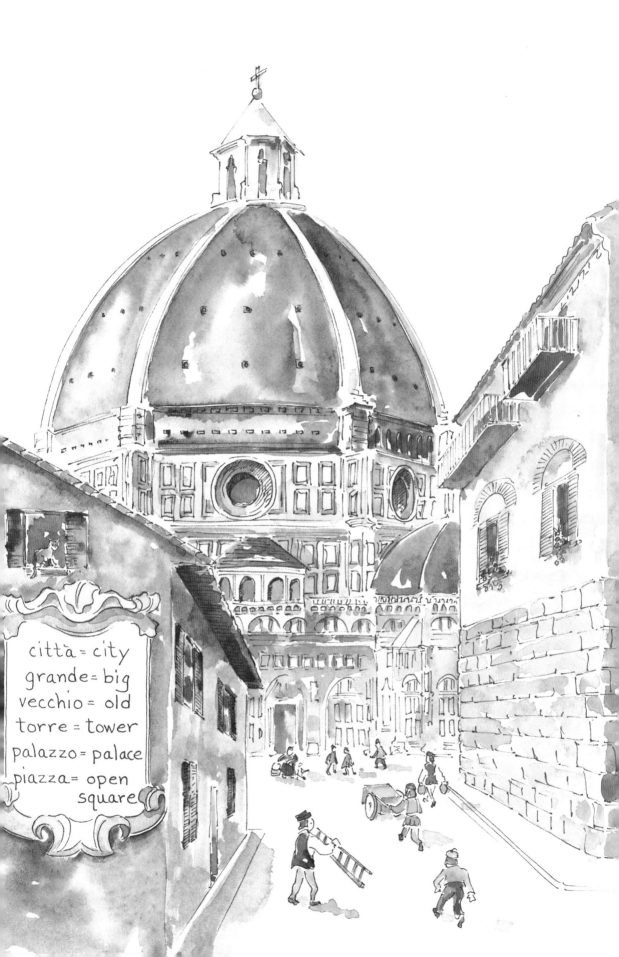

città = city
grande = big
vecchio = old
torre = tower
palazzo = palace
piazza = open
 square

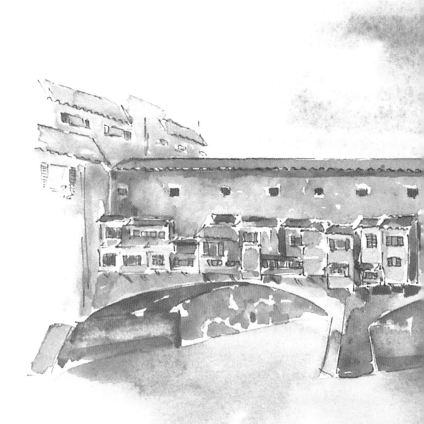

\mathcal{P}erugino often crossed the Arno
River on the oldest bridge in
Florence—the Ponte Vecchio.
Along the way he sometimes
stopped to visit the shops that
lined the bridge. Down below,
along the water's edge, children
played among the boats and docks.

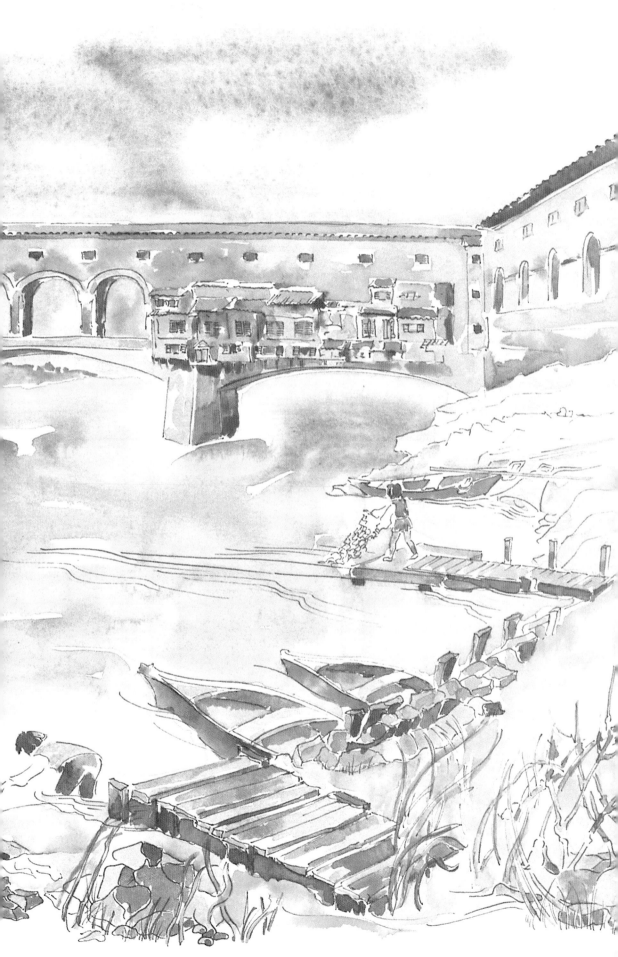

\mathcal{P}erugino's friends Leonardo and Sandro were also artists in Florence. The three worked together as apprentices in the large workshop of Andrea del Verrocchio. Later, Leonardo and Sandro became famous as Leonardo da Vinci and Sandro Botticelli.

During the Renaissance in Italy, many wealthy families collected art, antiques, and beautifully made books. The galleries, courtyards, and gardens of their palaces and villas were filled with paintings and sculpture. Scholars throughout Europe came to learn and teach in Florence, and young artists like Perugino were influenced by them.

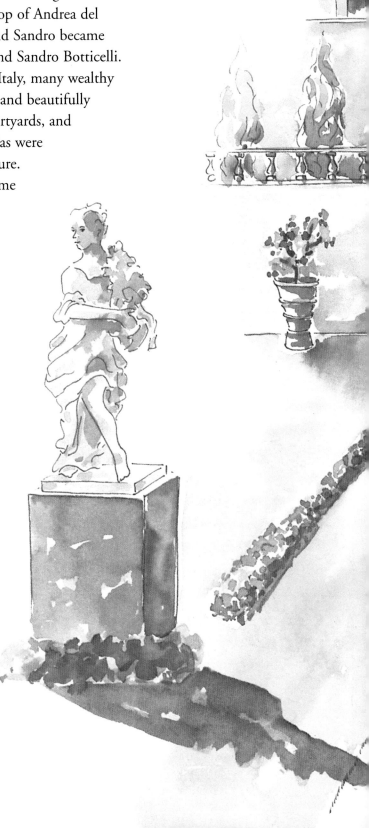

calze = hose
giacca = coat
fiore = flower
statua = statue
artista = artist
giardino = garden

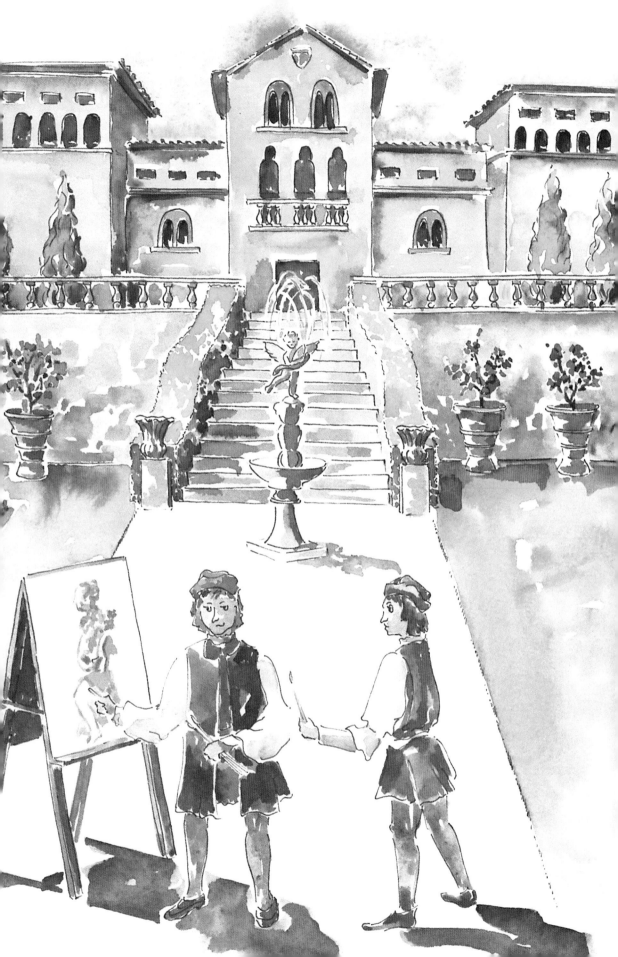

*T*he streets of Florence were often filled with excitement. Parades, festivals, and contests brought people out in their finest clothing, riding their fastest horses. Bullfights, horse races, track meets, and athletic tournaments took place in the piazzas. Clowns, court jesters, and musicians also took part in these events.

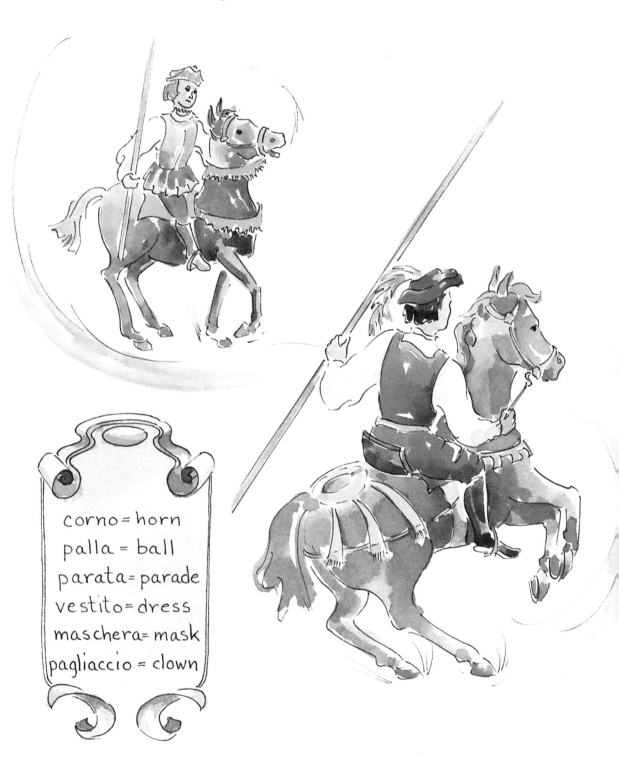

corno = horn
palla = ball
parata = parade
vestito = dress
maschera = mask
pagliaccio = clown

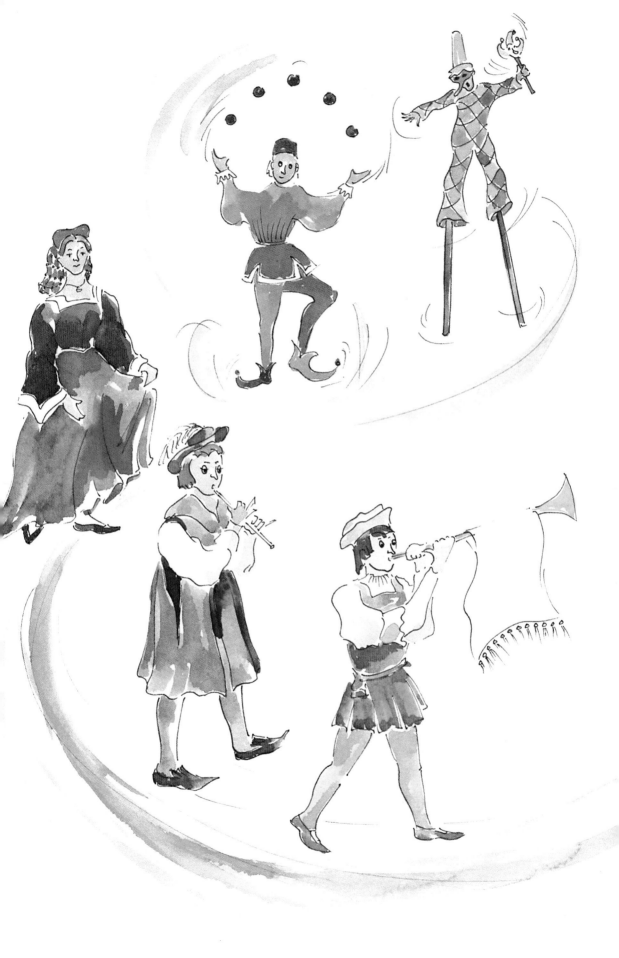

*T*he exuberance of the Renaissance was reflected even in the clothing people wore. Men often wore short, fitted garments and colorful tights. Their shirts had full sleeves and tight wrists; their coats often had side slits for the arms. Shoes with pointed toes were common. They originated in Poland, but they eventually became stylish in Italy as well as in other European countries. The length of the toe was determined by one's wealth.

The toes of commoners' shoes were restricted to six inches. Gentlemen wore theirs at twelve inches, and the shoes of noblemen might be two feet long!

\mathcal{W}omen wore long gowns with full skirts, tight bodices, and loose sleeves. Some sleeves had side slits that allowed the chemise underneath to show through. Women wore their hair long, usually keeping it in place with skullcaps or decorative nets.

\mathcal{S}ometime after he returned from Florence to Perugia, Perugino received an invitation from Pope Sixtus IV in Rome. The pope was rebuilding the city: already there were new streets, new bridges, and new hospitals. The finest artists from Umbria and Tuscany (the region of Italy where Florence is located) were invited to decorate the pope's new chapel. Perugino was asked to be the coordinator of the project. Little did he know that this chapel would in time become very well-known for the art that adorns its walls, the ceremonies that take place there, and the important position it occupies in the Vatican, the center of the Roman Catholic Church. Named after the pope who had it built, this chapel is called the Sistine Chapel.

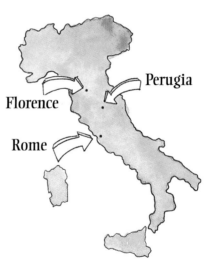

Florence

Perugia

Rome

carro = cart
scarpa = shoe
cappello = hat
cavallo = horse
sentiero = road

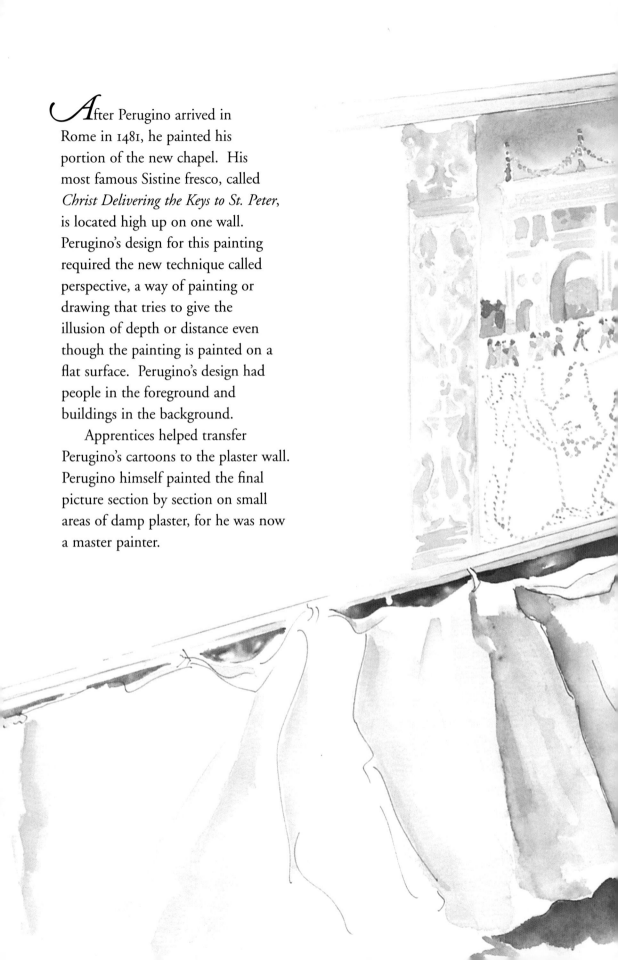

After Perugino arrived in Rome in 1481, he painted his portion of the new chapel. His most famous Sistine fresco, called *Christ Delivering the Keys to St. Peter*, is located high up on one wall. Perugino's design for this painting required the new technique called perspective, a way of painting or drawing that tries to give the illusion of depth or distance even though the painting is painted on a flat surface. Perugino's design had people in the foreground and buildings in the background.

Apprentices helped transfer Perugino's cartoons to the plaster wall. Perugino himself painted the final picture section by section on small areas of damp plaster, for he was now a master painter.

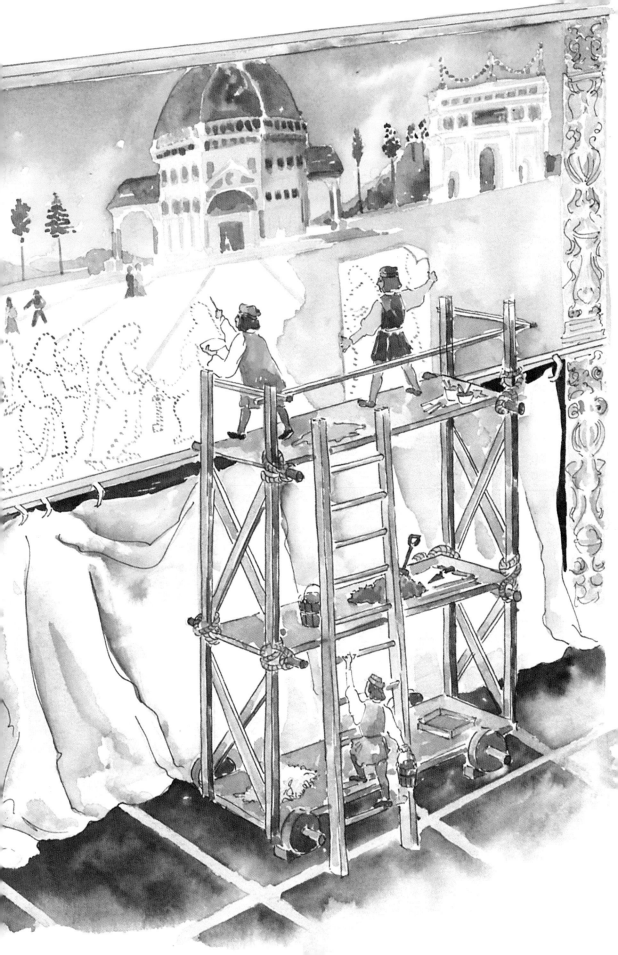

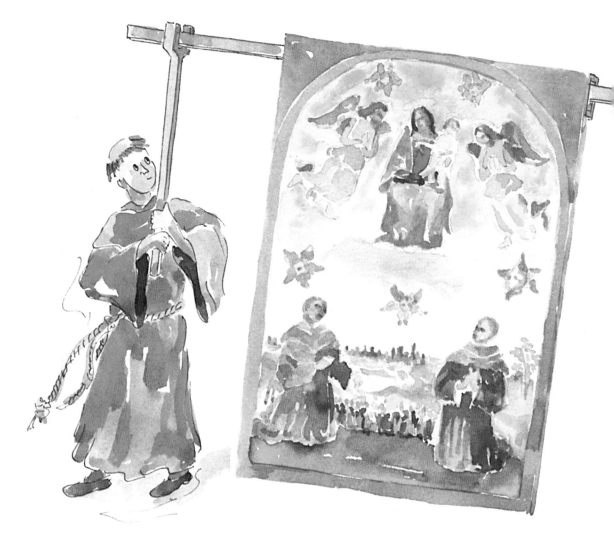

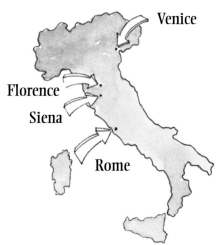

Venice

Florence
Siena

Rome

After he had completed his work on the Sistine Chapel in Rome, Perugino gained more attention for his artistic talent. Later he was asked to paint frescoes and altarpieces in Florence, Siena, Venice, and his hometown, Perugia.

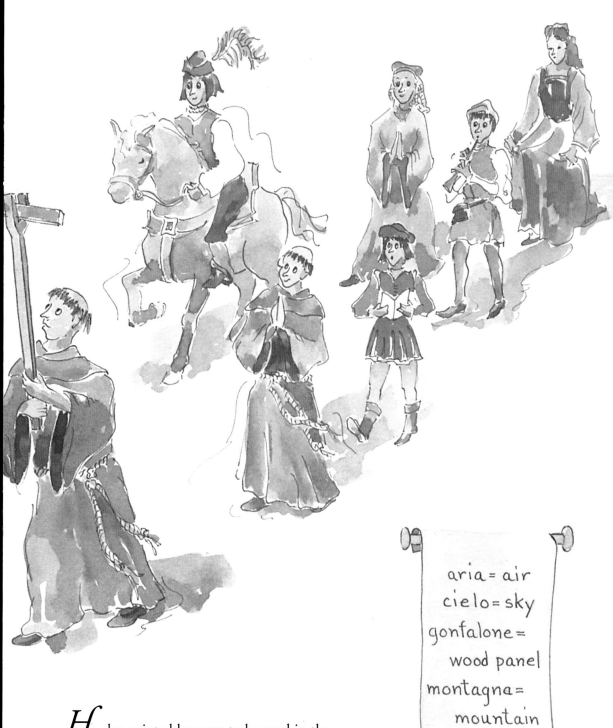

aria = air
cielo = sky
gonfalone =
 wood panel
montagna =
 mountain

*H*e also painted banners to be used in the religious parades of Perugia. At that time banners were painted on boards or canvas, and the pictures often looked flat. But Perugino's banners amazed everyone. His mountains, sky, and distant cities looked like they were three dimensional.

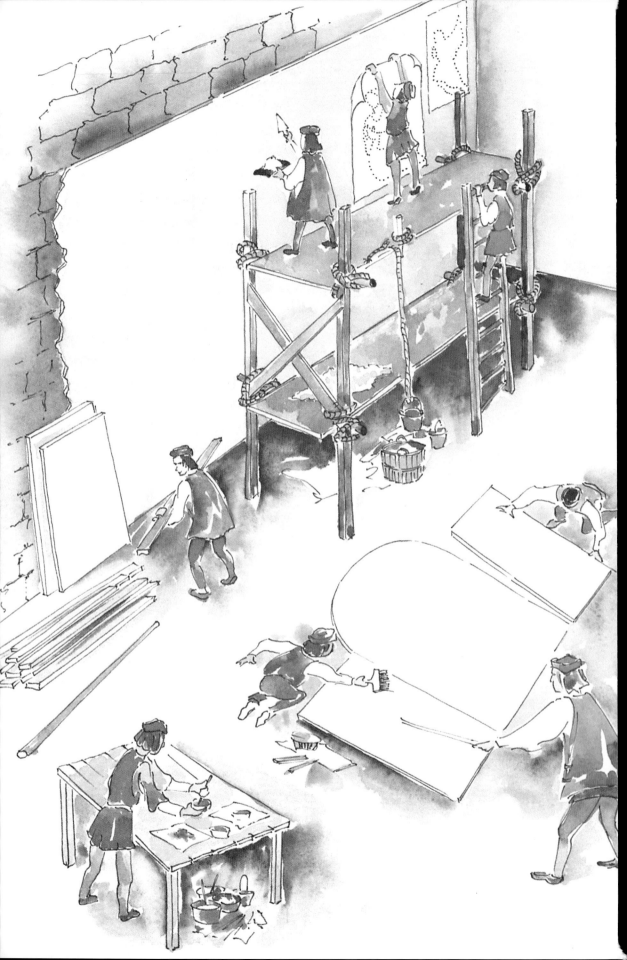

\mathcal{A}rt critics talked and wrote about Perugino's work. His use of perspective, light, and shadow made everything he painted look real, and the gracefulness and color of his paintings pleased everyone. His workshop attracted young artists from other European countries, including Spain, France, and Germany.

Today we can still view the simple beauty of Perugino's compositions in frescoes, drawings, and altarpieces. His graceful style and clarity continue on in the painting of his student Raphael, who became a famous master painter. After Raphael died in 1520, Perugino completed one of this master's unfinished works.

From Perugia to Florence, Rome, and Venice, Perugino's path followed the twists and turns of Italian history and art. As apprentice, as master, and as teacher, "the one from Perugia" was a significant contributor to the art of the Italian Renaissance.

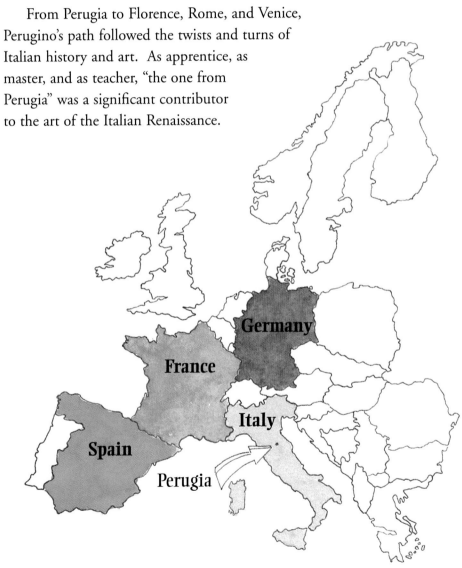

Glossary

altarpiece: the painting, carving, or other work of art above and behind an altar

apprentice: a person bound by an agreement to work for a specific amount of time in return for instruction in a trade, craft, art, or business

cartoon: a preliminary sketch, similar in size to the fresco, mosaic, tapestry, or the like that is to be copied from it

chemise: a long-sleeved, white linen undergarment with ruffles at the wrist and neck that was worn by Renaissance women; it showed at the wrist, at the neck, and through the slits in the sleeves of the outer dress. Eventually it evolved into a full-length garment.

egg tempera: a kind of paint made from pigments mixed with water and egg yolk

fresco: painting done on damp plaster with water-based paint

master: a person qualified to teach apprentices in a particular trade, craft, art, or business

perspective: a technique for rendering three-dimensional objects and spatial relationships on a two-dimensional surface

piazza: a public square in an Italian town

pigment: a colored powder (made from minerals, berries, flowers, or other organic materials) used as a coloring agent

Renaissance: a period in European history—beginning in the fourteenth century and lasting into the seventeenth century—when revolutionary changes took place in art, literature, science, religion, and philosophy. Many of these changes were influenced by a rediscovery of the classical traditions of Greece and Rome. The Renaissance began in Italy and spread to other countries.

skullcap: a small, brimless, close-fitting cap worn on the crown of the head

Sistine: of or relating to one of the popes named Sixtus; of or relating to the Sistine Chapel

sizing: a glaze or filler for porous materials like paper, cloth, and wall surfaces, usually made from a mixture of glue and clay, wax, or plaster

How to Say It

arco: AHR-ko

aria: AH-ree-ah

artista: ahr-TEE-stah

bucato: boo-KAH-tow

calze: KAL-tseh

calzino: kal-TSEE-no

calzoni: kal-TSOH-nee

camicia: kah-MEE-cha

cappello: kahp-PEHL-low

carro: KAHR-row

cavallo: kah-VAHL-low

cesta: CHEH-stah

cielo: CHEE-eh-low

città: cheet-TAH

corno: KOR-no

fiore: FYO-reh

giacca: JAHK-kah

giardino: jar-DEE-no

gonfalone: goan-fah-LOW-neh

grande: GRAHN-deh

maiale: my-AH-leh

maschera: MAH-skeh-rah

montagna: moan-TAHN-nyah

pagliaccio: pah-LYAHT-cho

palazzo: pah-LAHT-sow

palla: PAHL-lah

parata: pah-RAH-tah

piazza: pee-AHT-tsah

pollo: POLE-low

scarpa: SKAHR-pah

sentiero: sen-TYEH-row

statua: STA-tyou-ah

torre: TOR-reh

vecchio: VEK-kee-oh

vestito: veh-STEE-tow

uccello: oot-CHEL-low

Colophon

℘ *This book was produced*
digitally by Aaron Phipps using a Power
Macintosh 7100⁄66 computer. It was paginated with
Quark XPress 3.31. ℘ *Type was set with Garamond 12 point*
on 4 point leading. Title text is Ellington. ℘ *Original art was*
photographed to 4 x 5 negatives and transferred to Kodak's
Photo CD Pro for later processing in Adobe Photoshop 4.0.
℘ *The electronic files were sent on CD-ROM to Typecraft*
Inc. Lithography in Pasadena, California, for
imaging from computer to plate using a
CREO Trendsetter. ℘ *This book was*
printed on a 40" six-color
Heidelberg press.

AAP · PEREGRINATIO TEMPORALIS · ANNO DOMINI · MCMXCVII ·

✝